# ALL THE WAY HOME

*Best wishes —*
*Robert Sexton*

Also by the author
*The Morning People*
*An American Romantic*
*Journeys Of The Human Heart*

 design on book cover is registered in
U.S. Patent and Trademark Office

ISBN: 0-88396-417-1

Printed in U.S.A.
Second hardcover printing: January, 1996

# ALL THE WAY HOME

*the art and words of*
## ROBERT SEXTON

**Blue Mountain Press** ®

Boulder, Colorado

For Bill Iverson
who—despite the brevity
of his years—
truly lived a life that mattered

*The world spins too quickly these days. The "advances" in technology and communication have accelerated its pace, so that instant gratification and instant obsolescence seem to have become the hallmarks of this period in human history. Some people are able to race with these changes and— simply by holding on—to believe that they have succeeded in this new world. Others cannot or choose not to keep up with this increased velocity and feel strangely alienated from the world into which they were born.*

*But there was a time when the world was a far more personal place. Then, people found pleasure in people; money mattered less; we were never without a moment to spare; and our lives were enriched by the frequent smiles and laughter we were able to share. Then, people felt at home on this planet; and in the company of their loved ones, they did not experience the loneliness and sense of loss so prevalent among human beings today.*

*Because I have continued to believe in the virtues of this older and quieter world, I have spent the years of my adult life searching for a place which has not been distorted by speed and "progress;" a place where— without compromise to the particular elements of my own nature—I could feel that I belonged.*

*This book is a pause; a reflection; a remembrance. Within its pages I have tried to re-capture the spirit of an era when the world spun more slowly; when people dared to believe in dreams; when there was time enough for human love to grow.*

*I hope the images I have presented here will recall and clarify the enduring qualities of your own life; and that—wherever you are at this moment—this book will serve as a worthy companion and comfort you as you journey all the way home.*

*Ile Saint Louis,*
*Paris*

*noon*

Nine thousand miles away, most of my friends are deep in sleep. For there—in California—it is just after three o'clock in the morning; and the stars I saw through the little window of my room last night are above them now.

Six thousand miles away, the first light of dawn is sifting through the curtains of my parents' bedroom. My father, an early-riser, may already be awake. But my mother is surely still asleep and dreaming, perhaps, of days when her children were young and near to her. If that is her dream, the New Jersey morning will find her feeling a bit lonely: for my sister and her daughter are miles away; my brothers and their families are further still; and I am in Paris, sitting beneath a willow beside the Seine; and she cannot know that I am thinking of her and my Dad and my sister and my brothers and all of the people I love. But—for now—she is surely still asleep, as are they all; and, far from them, I can only hope that in some still and permanent part of their instincts they know that they are dearly loved. And knowing this, that each of them may breathe more deeply and sleep in greater peace. Then, when this day comes to them, its light may grace them with a bit more joy; and their steps may be lighter; and time may be kind to them.

For the past several days I have moved through this splendid city like a man made of vapor. Its sights and sounds and smells and tastes have delighted me; and—like a balloon—I have floated through its quarters, experiencing its wonders with wafting abandon. Happy? Oh, yes; I have

been happy here. Alive? Yes, oh, yes; for surely no other city so constantly dazzles the human senses. Complete? No. Not complete; for I have not been in Paris long enough to love anyone here. And the kind of love I am thinking of requires time. An affair may be spun of light and color and shadow. But the love that lives beneath the surface of the skin is built upon accumulated moments of feeling and experience; and this by its nature requires time. And fifteen days in the swirl of this city are not enough time to be touched and bound and broken and healed by a single person, as we are with each of the people we truly love.

So, far from them, I think of them—my friends and my family; and in the company of their smiling shadows, Paris becomes just a bit more complete.

Nine thousand miles away and six thousand miles away, they are asleep. Imagining their faces, so plain and vulnerable on soft moon-lit pillows, I think of myself among them. And I begin to remember my earliest recurrent dream. It began when I was just a little boy, and it has filtered through the mid-night hours across the span of my life. But in this dream I have no particular age. This is as it should be; for this dream comes from the heart, and the heart has no awareness of calendars and clocks. And neither are there events within this dream; for events happen to us, not within us. No; the dream that has flickered through the most tender nights of my childhood; my youth; and my adult life has turned upon a single element: a sense of place.

Even now, I can see it clearly. It is a bit of land, rich with trees and bright with flowers; and through some effort of my own, it has been peppered with a cluster of small and charming houses. These houses stand comfortably near to one another, and each is bathed with the clearest sunlight I have ever known. When my dream begins, I am just above and away from them; but as it progresses I am soon among them: I am a part of them. Silently doors swing open; windows are raised; and in that perfect sunlight I see the smiling faces of all the people I have loved. In this place my will and my efforts and my heart have created, they live; they are safe; and they know they will always belong. They come and go and return again; but wherever they are, they know this place exists for them: a place where— yes—they may be alone but never lonely; a place with shelter for both their bodies and their souls; a place to be and to simply be loved.

*Home.*

Then, always, too soon; the morning light would come again.

The dream would sift away.

I would reach to hold it, but too quickly it would fade; and I'd see only my empty fingers, stretched to its dimming light.

Awakening, I would find that I was alone in one of the dozens of anonymous rooms I've known, as—now—I am alone in this small park at the southernmost tip of Ile Saint-Louis. The day has turned gray here, and the sky threatens rain. The remembered joy and colors of the dream have gone once again. But just as the sun is somewhere beyond these clouds, the dream lives on just beyond this moment. And knowing that it would be there and that it would come again, over the years I would resolve to work each day so that the wonder of its promise might find fruition.

Soon, I thought. Soon. Not tomorrow. Maybe not this year. But it is not so far as yesterday, and not so distant as when it first began.

Believe and work, I would tell myself. Believe in dreams and work with joy. And then one day when the world turns around, and starlight and sunlight gently merge, you will find yourself in a shimmering place, and you will know you have travelled all the way home.

## DANS LE CIEL TOUT SE CONFOND
*(All Things Are Joined With The Sky)*

*A smile is a smile in Paris as surely as in Cheyenne.*
*Those who travel with an open heart know no foreign land.*
*The stars that shine on San Francisco speckle the nights*
*of Rome. And the sky and the air and the people there*
*are one with the ones back home.*

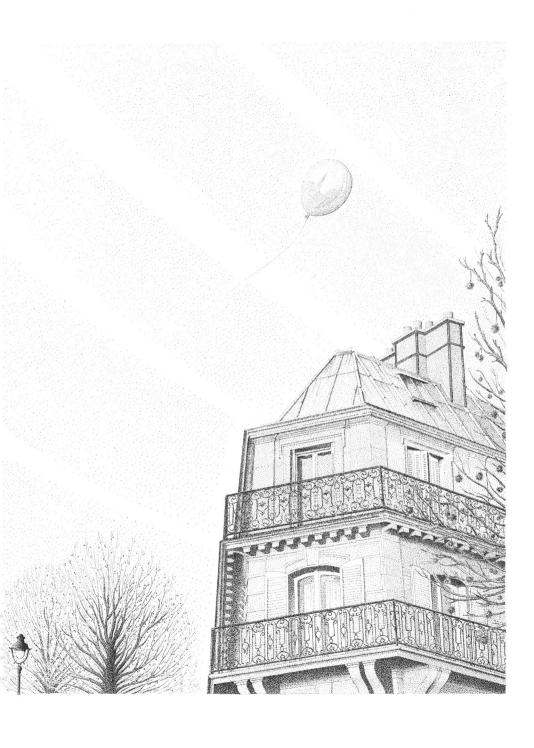

## TO A NEWBORN BABE

*The world is changed. A new life has entered; and with its delicate innocence, our hope is reborn. Of this we can be certain: the love we give will expand within and guide the course of this new life.*

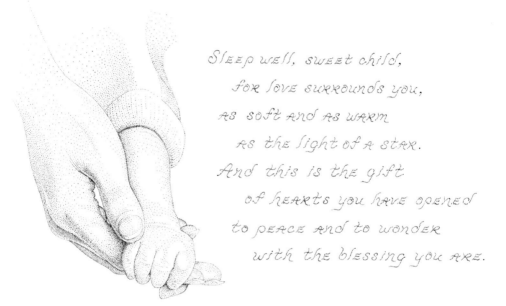

Sleep well, sweet child,
for love surrounds you,
as soft and as warm
as the light of a star.
And this is the gift
of hearts you have opened
to peace and to wonder
with the blessing you are.

## WINGS

*This world is not kind to dreamers; cynics and scoffers are everywhere. But if you have a dream, and your faith in it is strong, you must find the courage to move beyond those who would deny its realization.*
*You can do it. After all, we are born with wings.*

your dream is the gift of your own soul.
  But if its promise is to be fulfilled,
      you must turn your eyes from the world of men
          and dare to fly among the stars.

# THE POND

*In the new light of spring, tadpoles and minnows shimmered upon its surface. In summer, dragonflies and waterlilies floated within its dreamy mist. In the dusk of autumn, an armada of fallen leaves sailed to wherever its waves would take them. And late in winter, my skates drew silver circles upon its sleeping face.*

*In the years of my childhood, the pond was a calendar of the seasons and their wonders. But I didn't know then how well I would remember the silent lessons of its days.*

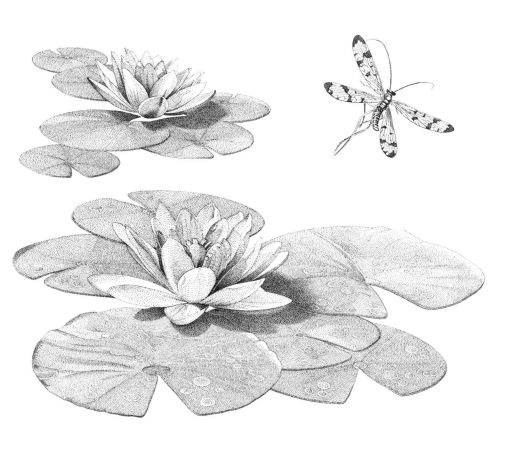

## UNTITLED #17

*In the process of living, so many little things demand our time and attention that it is important to retain a sense of perspective with regard to the center of one's life. The person or people who live there are the reason for our own joy and should consciously be given our deepest honor.*

This much I'll remember
when the rest of life
is through:
the finest thing
I've ever done
is simply
loving you.

## A FATHER'S GIFT

*When a father takes the time to share the content of his own heart—his dreams; his doubts; his resilient hope—he gives his child the power to believe in the possibilities of their own life.*

*By sharing his own humanity, he affirms their right to become all that they might imagine; all that their heart may guide them to be.*

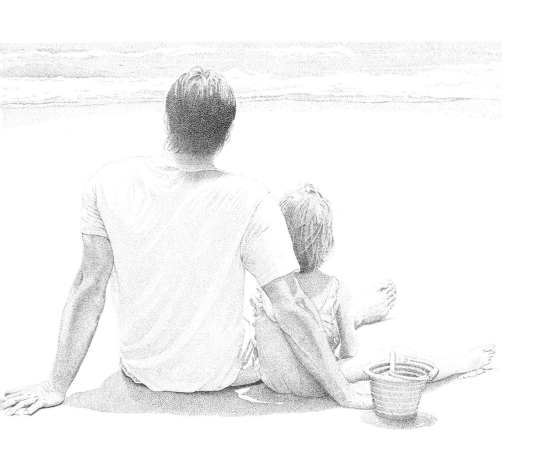

He gave so much of himself to me —
his time, his trust, his tender care —
that whatever else I may become
I will always be my father's child.

## CALICO

*For almost a decade this young lady was a part of my life. Then, as so often happens, we lost touch with one another when her family moved to another state. Now, years later, it is only memory that brings her near to me again. But in this quiet way she continues to brighten my life.*

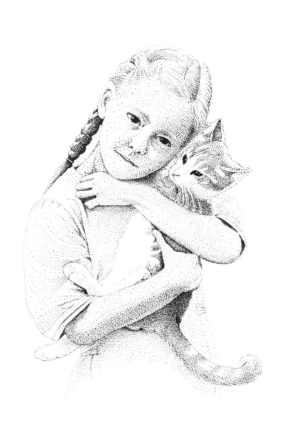

## UNTITLED #18

*Standing just a bit apart from those we love allows us to view the unique qualities they bring to this world. Seeing them as the individuals they are—as they exercise their own talents and gifts—also gives us a deeper understanding of our own love for them.*

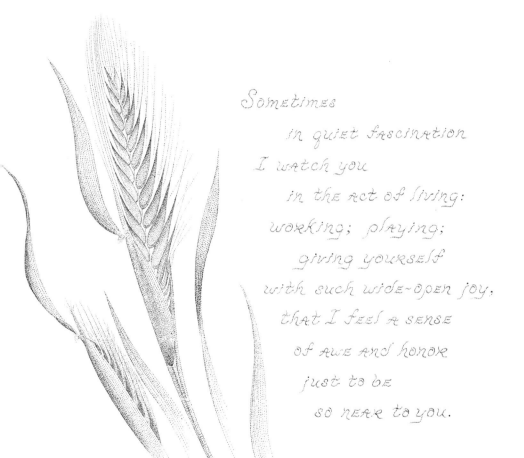

Sometimes
      in quiet fascination
I watch you
      in the act of living:
working; playing;
      giving yourself
with such wide-open joy,
that I feel a sense
      of awe and honor
just to be
      so near to you.

# WINTER DREAMS

*Adolescence is an awkward place. The world doesn't fit when you try it on, as if it were made for somebody else. And everyone else seems so sure of themselves, and you're only certain that you're not like them. No longer the child of scrapbook pictures, you wonder what will become of you; and you wonder if you will ever belong. And you dream of places—far away—and you really wish you had a car, for then you might find the person you are.*

*Out there, somewhere in this world, is there anybody else like me?*

# WINTER DREAMS

## THE SAILOR'S SONG

*If we are to live and not merely exist, it is essential for each of us to find the particular atmosphere where we most surely sense that we belong. For some, this may be a specific city; for others, any mountaintop. For me, this has always been beside, within or upon the sea.*

When I feel my spirit
    begin to ebb,
I know I've lingered
        too long on land
    and set the sail
        that guides my soul
    and hasten home
            to the sea.

## THE CLOSEST OF KIN

*Her kindness flows so quietly that the comfort she brings is scarcely acknowledged. Still, she continues to weave the fibers of love which have united our family. That is her nature. And that is her gift to each of us.*

If history records
this lifetime we share,
on the page I am given
you will be there.
The truth will be written
in line after line:
how you gave of your heart
and tended to mine.
And the world will then see
in each word of that pen,
with you as my sister
how blessed I have been.

# WORD OF HONOR

*Like flowers rising to meet the sky, we unfold
in the presence of a friend. Nothing is withheld, for the
trust we exchange allows us both to be all that we are.
There is no greater freedom and no more natural joy.*

Of all the gifts
life may bestow
none is so constant,
steady and sure
as the tender heart
of a friend.

## POSTCARD/Sunday Afternoon

*In the time of our lives, each of us encounters one or two people of such extraordinary goodness that we feel ourselves illuminated by the simple fact of their existence. Then, there is nothing for us to do but recognize the fact that we have been blessed by their presence, and that— from this blessing—we must learn.*

Sunday afternoon

# POST CARD

With all that you are;
with all that you do;
you have made this
a more beautiful world.

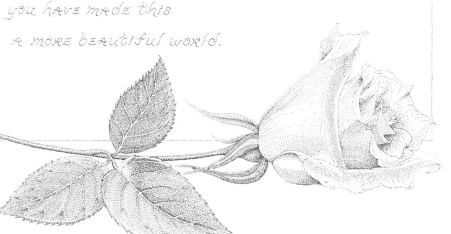

# THE COMPANY WE KEEP

*Because love requires courage, so many people choose to remain safely locked within themselves. But those who move beyond reticence and fear quickly learn that there is no security in isolation; that our lives unfold and gather strength in the company we keep.*

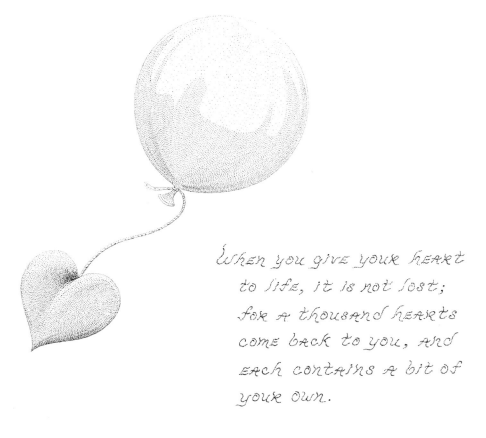

When you give your heart
to life, it is not lost;
for a thousand hearts
come back to you, and
each contains a bit of
your own.

*Washington Square,*
*San Francisco*

*late afternoon*

The sun is setting over my left shoulder as I write these words in a coffee house in this enchanted city. Its rosy glow lingers upon the faces of the few other patrons, and the shadows of our chairs lengthen on the tiled floor.

This city feels like an old coat around my shoulders now: loose-fitting; well-worn; infinitely comfortable. I moved here seventeen years ago, and though I have lived in several of the towns which surround San Francisco Bay since then, the city itself has remained the center of my love for this area. Though I no longer live within its borders, San Francisco is a part of the place I have come to think of as home.

Why? Looking out at the easy grace of these streets and these hills, I have no better answer than the one I found eighteen years ago, when I came to this city for what was to be a two-week vacation. The two weeks stretched to seven; and one day toward the end of that span, I found myself walking beside the Pacific at Ocean Beach, wondering why the anticipation of leaving had become so painful. And watching the breaking surf, and glazed by its cooling spray, these words came out of my own instincts, as clearly, as exactly, as I write them now:

*All things are possible here.*
*You are possible here.*

Wanting to know more about myself and my country, I had lived in many states; and—sooner or later—I had come to feel like a displaced person in each of them. The jobs I had held; the rooms I had occupied: these were

but work and shelter. They had never touched me; they had never reflected me: they had been a part of someone else's world.

Many of these places were fine and beautiful; and I had seen that other people lived within them with a full sense of contentment and completion. But though my body and mind functioned within them, my spirit—my individuality—was not nurtured by the elements which composed their characters.

For more than a decade I had wandered from one place to another and on again; and then—seeking nothing more than a vacation from the job I held in Florida—I had come to San Francisco.

From the moment I arrived I felt spiritually and emotionally connected to this place. The physical beauty of the city was awe-inspiring. Its colors; its tastes; its smells; even its weather: these were more refined and intense than in any place I had ever known. And with the clang of its cable cars, and the cry of its gulls, and the impossibly deep bellow of its foghorns; the city's voice seemed vibrant and yearning, like the voice I'd heard in so many midnights: the longing sigh of my own soul.

As it has done with countless other visitors, San Francisco dazzled me from the start with the power of its sensual attractions. But as the days passed, their predominance began to pale. Their brilliance remained, but I began to see that there was something more to this special place: something rare indeed on earth.

It was born of the city's people. They had come to this place from all over the world. Every race; every religion; every culture was represented: and by virtue of the simple fact that no single group could be counted in the majority, they had learned to live together and to celebrate their diversity. The city was a living kaleidoscope of ideas and traditions, colored by the gifts of each of its minorities. And with so many glittering cultural facets, the city had extended the parameters of its heart even further. For not only were the qualities of each group respected and celebrated, but the uniqueness of each individual was exalted as well. In such an environment the growth of each person would be limited only by their own resolve and the borders of their own dreams.

Shortly, I gathered together the bits of my life I had left in Florida; packed-up my old Dodge convertible; and turned back toward the misty city on the western edge of the country of my birth.

Not long after moving to San Francisco, I began to feel that the life I had imagined for myself might truly be fulfilled. I began to draw; and I began to write. For as long as I could remember, I had loved both of these arts; but until I discovered the environment in which they might flourish, I could not see that—in their exploration—lay the essential purpose of my life.

From the beginning my drawings have been characterized by the use of stippling: the composition of a work one dot at a time. Not only did this technique come most naturally to me, but I elected to remain with it for the discipline it demanded. Knowing in advance that each work would require weeks to complete, I would have to be certain from the start that the subject or theme of each drawing was of compelling importance to me.

It is with the same sense of urgency that I have regarded the words which characterize my works. In all that I write, I have tried to share that which—by my own experience—I have found to be true and enduring and quietly beautiful. As we move through life, the world presents a myriad of conflicting perceptions and values to each of us. In my work I have tried to focus on that which remains when fashion has faded and passion moves on. The central themes of my work are those which have stood the test of my own time: the love of family and friends; the wonder of the natural world; the dignity and potential of each human being; and the resilient power of the human heart.

My work has grown to be both the reason and the means for my life. As such, it has also become the foundation of the place I call home. I know now that—without it—the dream my spirit began to spin so long ago would have remained only a tender vision of an impossible world. Now, that world, that place, is very near.

As the shadows of twilight deepen in this little cafe on Washington Square, I gaze out at the passersby, hurrying home from work. They are the people of San Francisco: the individual participants in the creation of an atmosphere of compassion, freedom and hope. Without even knowing me, they have given me so much. Whenever I am among them now, I feel a quiet sense of comfort and gratitude; and I resolve to continue the spirit they extended to me. To the longing soul I brought to this city, it shone like a beacon above the fog; and for the first time in my life, I had the sense that here, at last, I was almost home.

# CALIFORNIA

*It is in her quiet places that California most surely reveals herself. For when the senses are not distracted, the essence of her beauty becomes apparent. And that is the quality of her light. More intense than elsewhere, it deepens colors and etches the lines of shadows, so that each living thing seems just a bit more alive.*

*In quiet places you will come to know her. And then her light will never leave you.*

## UNTITLED #19

*In recent years it has not been fashionable to speak of our
need for one another. But love is not guided by fashion.
When our lives have truly been graced by the presence of
another, we know how necessary they are to our happiness.
And we tell them.*

This stillness at my center;
This trust within my soul;
This perfect peace within my heart;
This sense of being whole:
These are new within my life;
They were not here before.
These are you within my life;
And I need nothing more.

## A MOTHER'S GIFT

*After she has given birth, a mother begins to give life. By teaching her child to love, she opens the doors through which his or her full potential may be realized. And through every day of her child's life, a mother's gift continues to unfold.*

She gave me love, as well as life;
   so whatever goodness I may bring to Earth
      began with the gift of my mother's heart.

## MORNING

*The attitude with which we move through each day is formed in the first few moments after we awake. If we take that time to focus on the beauty and wonder of this world, our activities and relationships in the hours that follow can all be in celebration of life.*

## UNTITLED #20

*If there is a central theme to all my works, I think that it must be this:*

> *Be gentle with those who are dear to you. The world can so easily break them. But your tenderness can comfort them in the midst of chaos; and your hands and your words can elevate them—whole—above the convulsions of change.*

Time may change
    the place where we live,
    the people we know,.
    the things that we do.
But time cannot alter
    the vow I have made:
    as long as I live
    I'll be there for you.

## THE BEST OF MEN

*To appreciate my brothers, I need only briefly imagine my life without them. Then the immense gift of their presence becomes wholly apparent, and I clearly see the richness they have given to each day of my life.*

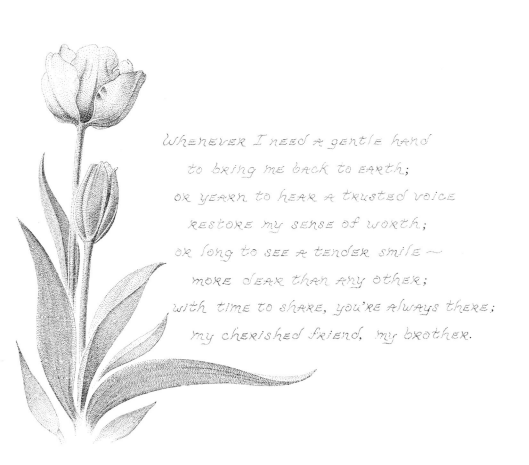

Whenever I need a gentle hand
to bring me back to earth;
or yearn to hear a trusted voice
restore my sense of worth;
or long to see a tender smile —
more dear than any other;
with time to share, you're always there;
my cherished friend, my brother.

## MONTANA

*Granted time on this Earth, we have received an immense and wondrous gift. Everywhere, there is so much beauty! Can a life possibly be long enough to experience more than the merest bit of its grace? When the end of my time has come, I will only regret the roads I was not able to travel and wonder at the mysteries to which they led.*

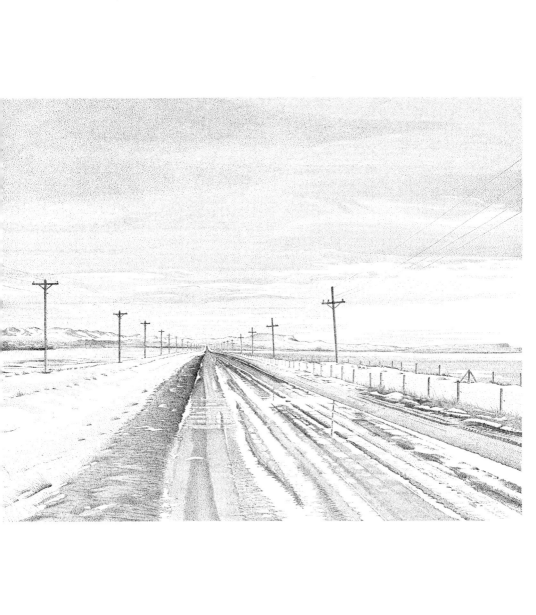

# REMEMBRANCE

*Though the circumstances of human life may draw us apart, the love we have given to one another continues to spin through time and space. As life is a continuously nurturing process, so is love; and the moments we share can never be lost, erased or denied. To honor the past for the vibrancy of its life is to honor this hour and all time yet to come.*

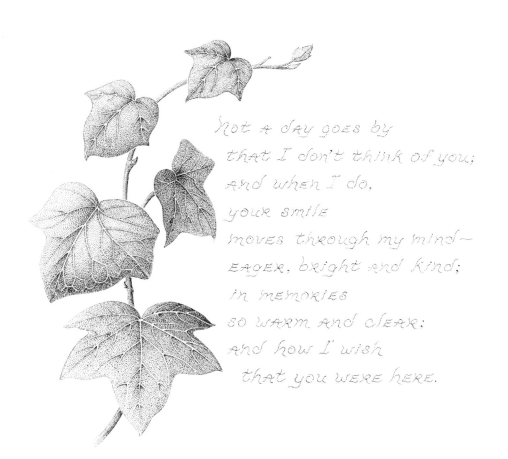

not a day goes by
that I don't think of you;
and when I do,
your smile
moves through my mind—
eager, bright and kind;
in memories
so warm and clear;
and how I wish
that you were here.

## THE FIRST SNOW

*An integral part of the natural cycle of all living things is the season of rest. That growth may be continued; that the elements which sustain life may be replenished; that the strength required to survive and thrive might be renewed: the stark beauty of winter returns and silently nurtures each creature, each plant and each of us.*

# FROM THIS DAY FORWARD

*The essential part of our humanity is the desire to love and to be loved. When those we care for find their longing fulfilled, their joy becomes our celebration. For with their pairing, they renew our faith; validate our hope; and confirm the dignity of our own dreams.*

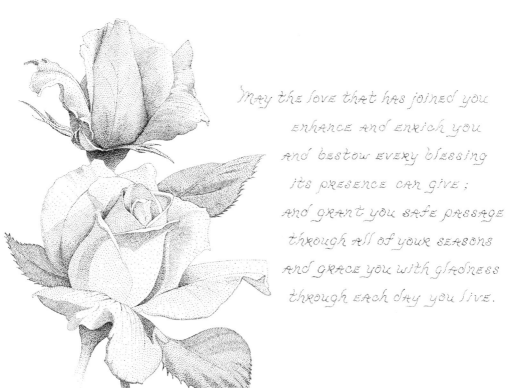

May the love that has joined you
enhance and enrich you
and bestow every blessing
its presence can give;
and grant you safe passage
through all of your seasons
and grace you with gladness
through each day you live.

## A NOTE TO A FRIEND

*So often we seem to keep our deepest feelings locked within us. Perhaps this is because we feel awkward with the expression of their intensity. But with our true friends everything is acceptable—even our awkwardness. And it is by the expression of our feelings that we validate and honor those who have given substance to our lives.*

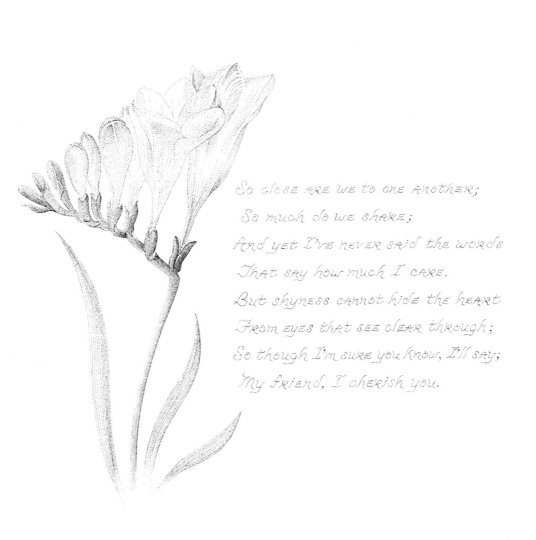

So close are we to one another;
So much do we share;
And yet I've never said the words
That say how much I care.
But shyness cannot hide the heart
From eyes that see clear through;
So though I'm sure you know, I'll say;
My friend, I cherish you.

## IN OUR TIME

*The course of love is guided by the visions we exchange;
for the dreams we share light the way between the present
and all the time to come. Love gives us the courage to
imagine our future lives; and love itself is nurtured
when we dare to see beyond this day.*

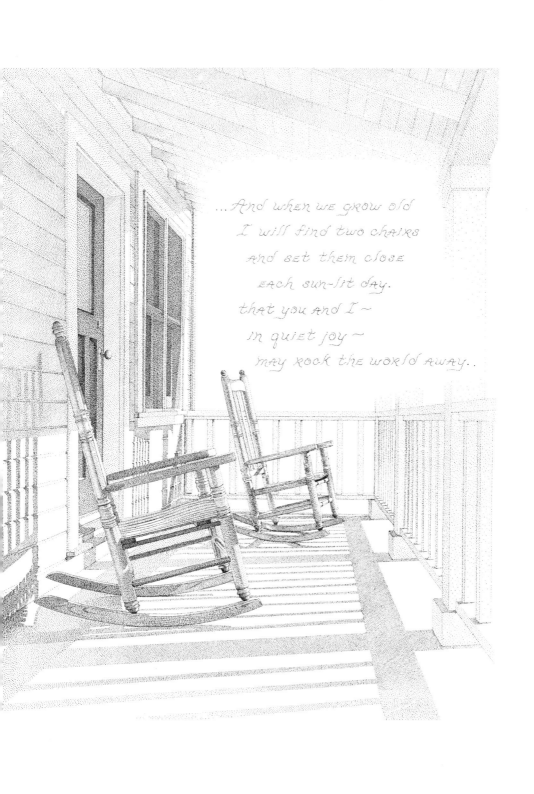

...And when we grow old
I will find two chairs
and set them close
each sun-lit day.
that you and I ~
in quiet joy ~
may rock the world away..

## ALL THE WAY HOME

*In the eyes of others, it isn't much. A bit of land. A few small rooms. Undistinguished, except by this: this is the place where I belong. This is the place where I can work and love and be myself. This is the place I can always come back to; where I will always be welcome; where I can rest my head and watch the stars, when night claims the world, and it is time to go home.*

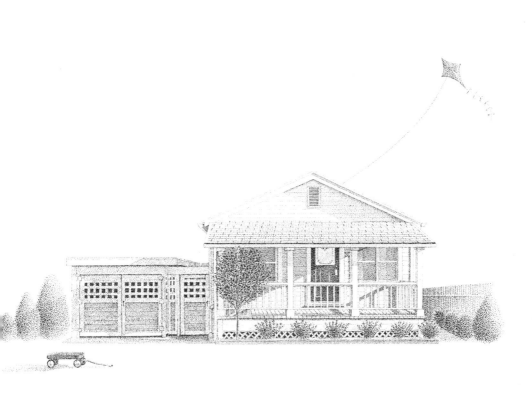

*St. Helena,*
*California*

*midnight*

At this hour it is the stillness of this town which is most remarkable. Sitting on my front porch, I look out at the stars; and I can almost believe that the only sound on this earth tonight is the sweet, haunting song of the mockingbird in the distant wood. The stars seem so near that, if they had voices, one could probably hear their song, too—tinkling across the million miles of quiet space between their home and my own.

My neighbors have all gone to bed. Their houses are dark; but the moonlight defines their walls and roofs with its frosty glow. They are all good people—loving to one another; generous and kind in their acceptance of me. For a moment I wonder what their dreams will be tonight. Then, again, the familiar refrain of my own old dream begins to spin; and watching the stars, I live within its warmth.

*Home.*
*"Rich in trees and bright with flowers."*
*Home.*
*"The smiling faces of all the people I have loved."*
*Home.*

And breathing deeply of this starry night, I feel the expansion of my lungs; then—letting go—exhale the air and stars and years of yearning; and return to earth; this time; this place: this rocking chair on the covered porch of this little house, where a candle burns that I may write; where sylvan peace attends night; where tender time has settled me; where I once dreamed I'd someday be.

Home.

When longing becomes belonging, the heart is finally home.

From the first moments I spent here, St. Helena has sparked my remembrance of the town where we lived when I was a boy. And though this sense of recognition has been enhanced by their visual similarity, the two towns are joined more deeply within me than a common image would allow. Rather, they are linked by a quality of affirmation: an instinctive sense that here I can fully live my life as I had hoped I would live it when I was a boy; that—here—I might become the man that—there—the boy had dreamed he'd be.

When your sense of self and your sense of place naturally merge with ease and grace, like the words and music of a tender song; then you will know where you belong.

Within the stillness of this hour, it is difficult to imagine that—for so many years—I feared the night. But when you do not know where you belong; when you only know that you do not belong where you are; there is no continuity to your days. Each one is a separate struggle with your own sense of displacement; and when this feeling continues through dozens of places and decades of years, you begin to wonder if you will ever know a home. And more and more, your nights are haunted with the specters and sounds of being lost.

I had lived through thousands of such nights and silently borne their weight. Then—two years ago—just as they had guided me to my work, my instincts turned me toward St. Helena.

Now, the nights come more easily: they simply join the days. The mustard flowers which graced the fields at dusk today will smile again in the morning light. The gentle breeze which brushed their faces will return with the sun and brush my own. The laughter of children will be heard again, freshened and strengthened by their hours of sleep. Life will go on: the children will grow; the seasons will change: but life will go on, renewing itself. And the sense of purpose which marked my day will rise again with the coming dawn.

Now—with the simple faith belonging has brought me—I can put this day away without regret or guilt or fear, knowing the things I have left undone will be done tomorrow. For—in my work; in my life—my days are now joined by the peace and rest the night allows. And even in imagining the

end of my days, I can begin to believe that I may know that, though I did not do all I might have done, I did the very best I could. And—with that—I may be allowed to sense that, despite the legion of my flaws, I lived a life that mattered. For—from the town of my childhood to this town in the West—that has been my abiding goal: to live a life that matters. And it is only here—in the serenity of this valley—that I have finally begun to believe that I may.

The mockingbird has gone to bed. The stillness of the night is almost complete. Now, the only sounds I can hear are the scratch of my pen upon this page and the rise and fall of my own breath.

Now, I live within a dream. With St. Helena I have found the place where the people I love may always know a door is unlocked; a heart is open; shelter and space and peace await them. And at this moment, gazing across the length of this porch, I feel a soaring sense of joy; knowing my parents have crossed these planks; my sister, too; and so many friends. And each of them have left with me a bit of themselves to adorn this place: a trace of their love they will find again, cherished and glowing, upon their return.

The candle is low, nearing its end. In a very few moments its light will be gone. Then, only the brilliant stars will remain for other travellers to follow through this night. Putting away my pad and pen; putting away the fullness of this day; I will turn down my bed and open the window, that I, too, may watch the stars again just before I sleep.

But in this last moment of candlelight, if one more wish could come true; I'd move through the paper wall of this page, and pass on this flame to you: that it might spark your own dream's taper, and give you the power to see that the life you imagined in the heart of your childhood—with faith—may yet come to be. Trust in your instincts; be kind to yourself; sow love wherever you roam: and your soul in its wisdom will guide every footstep and carry you all the way home.